The Mountains Wi
book. Garth Gilch
rare souls whose li.
radiate nature's ecstatic presence
and benevolence. Each poem is a
doorway inviting the reader to partake
in an intimate connection with
wildness. — **Joseph Bharat Cornell,
founder of Sharing Nature Worldwide,
author of** *The Sky and Earth Touched Me*

Garth Gilchrist is a man with a
mission: to delight in language and
insight, to help restore the soul of
the world. — **Barry Spector, author of**
*Madness at the Gates of the City: The
Myth of American Innocence*

"Read aloud, Garth's poems vibrate
with a lust for life and too, a reverence
for all living things. A masculine erotic
energy flows easily through his poems.
His lush language and his love for
great nature rise from the page and
swell the reader's heart. Yes."
— **Doug von Koss, Men's movement
leader and singer of the heart**

The poems and photos in Garth
Gilchrist's new collection, The
Mountains Within, seem to flow
from the mountains themselves. This
gorgeous volume is the story of a
reciprocated love affair between a
man and his home planet. John Muir
would be at home in these pages!
— **Larry Robinson, former mayor and
poet laureate of Sebastopol, California**

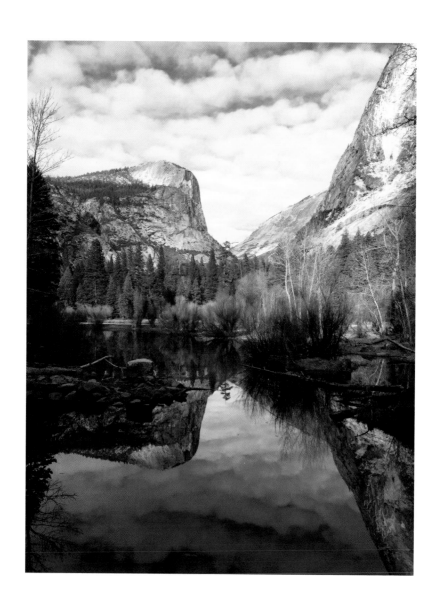

The Mountains Within

POEMS OF THE WILD

with images

Garth Gilchrist

For True, one of the most
poetic inspired souls I know —
with love, Garth

REGENT PRESS
Berkeley, California

[paperback]
ISBN 13: 978-1-58790-354-0
ISBN 10: 1-58790-354-7

[e-book]
ISBN13: 978-1-58790-355-7
ISBN 10: 1-58790-355-5

Library of Congress Catalog Number: 2016935325

Cover Photo by Shi Jean Bon Ley

Manufactured in the USA
REGENT PRESS
Berkeley, California
www.regentpress.net

Wonderful how completely everything in wild nature fits into us, as if truly part and parent of us. The sun shines not on us but in us. The rivers flow not past, but through us, thrilling, tingling, vibrating every fiber and cell of the substance of our bodies, making them glide and sing. The trees wave and the flowers bloom in our bodies as well as our souls, and every bird song, wind song, and tremendous storm song of the rocks in the heart of the mountains is our song, our very own, and sings our love.

— JOHN MUIR

Table of Contents

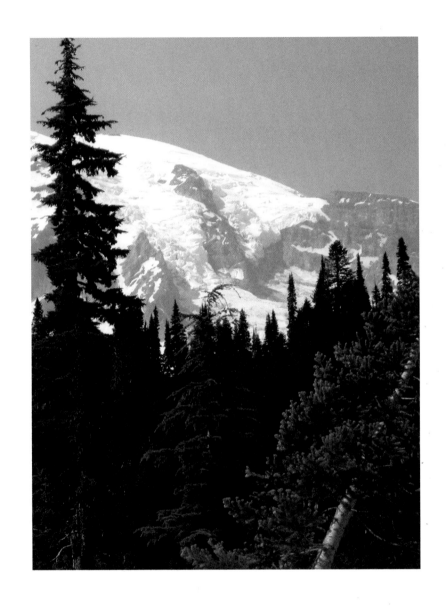

Preface

I grew up roaming the woods and scrambling up western Washington's great trees, wind songs in my ears and storm music calling me to swing open the windows at night. I think I grew wilder rather than tamer. I relished climbing the tall firs and cedars, even after dark, though I never told my mother. I felt wonderfully awake up in the branches bathed by starlight and sifting breezes.

When I was older, the Cascade and Sierra mountains sent currents of keen aliveness flowing up through my feet from the landforms and bright elements of stone and water as I walked, entering as well through ears, eyes and breath to create a living geography of more than beauty within me. Water's freshness and clarity, stone's cool solidity, trees' vitality and a plethora of sweet and subtle wild presences flowed into my inner landscapes as I made myself physically intimate with them. An increasing wonder full of quiet joy grew for what I came to call The Great Life.

Ordinary and extraordinary troubles assailed my adolescence. My father died of a heart attack, my mother got cancer, and I felt the loneliness of my differentness. Succeeding decades delivered wondrous triumphs, and then horrendous catastrophes. Yet all the while, an underlying comfort and strength flowed steadily to me through the land, sustaining and assuring me that beneath the adventures and misadventures of my personal life, The Great Life was steady and unchanging. A friend of mine calls it the Infinite Stream.

These poems spring from moments awake to that Life, comprising a partial testament to decades spent in love with

wildness. The poems hint at a way of perceiving the world born of felt connection that many mountaineers discover, in which the senses awaken a more essential knowing, the keenly perceived blessings of creatures, elements, original presences, and something indefinably sacred that flows through it all.

Our old ancestors lived in intimate connection with the wild, and children have an old instinctive, insatiable curiosity, a wonder for animals, a delight in water, and not long ago grew up roaming woods and streams, or wild tracts. Even after leaving the land and the farms, many people still tended flower and vegetable gardens. Our world these days is increasingly cramped, digital, media-driven, virtual, unrelentingly stimulating and stressful for young and old alike. We forget about nature as a part of ourselves and we lose something essential to our humanity.

Although humans' invasion and destruction of land, waters, species and ecosystems increasingly alarms us, we might be just as alarmed if we grasped the implications of the waning and disappearance of Nature within us, as our connection with wildness grows tenuous.

Words only reflect what they describe, yet somehow they do hold wondrous power to enliven us. My hope is that these poems stoke up the old fire of your connection with the original world, that they spark the bright, strong Life beneath your life, and remind you or newly entice you to stride back out into the living world and immerse yourself in its life-giving presence, inside and out. We can renew ourselves, and re-enliven our will to steward that which sustains us.

Garth Gilchrist
August 2016

A Note About the Photographs

The photographs in this book I've taken in my travels and explorations in the American Southwest, the Pacific Northwest, along the California Sierras and coastlines, in China, England and elsewhere. The photos that face the poems sometimes match the places or moments that the poems describe, but often are not literally representative, but compliment the qualities the poem expresses. In a couple of places you may note factual mismatches. For instance, the poem Hunter, inspired by a goshawk, is faced with a photograph of a red-shouldered hawk. Oh well. I hope you enjoy the photographs as you do the poems. Location notes about the individual photographs can be found on page 111. Photos in the body of the book were made by Garth Gilchrist. The cover photo is by Shi Jean Bon Ley.

Acknowledgments

My father, Charles Allen Gilchrist, loved trees and instilled that love in me. He took me to the mountains and streams, and also taught me to love words, poems and stories. John Muir's words, and those of Emerson, Thoreau, Whitman, Sigurd Olson and Aldo Leopold got me excited in my twenties. Then a host of big voices clambered in: Wordsworth, Hopkins, Snyder, Jeffers, Berry, Dillard, Oliver, Whyte, Hirschfield, Chief Dan George, Hyemeyohsts Storm, Nancy Wood, David Abram. All fed my excitement as bits of their inspiration lodged in me. Yogananda deepened my sense of what Life is. Lesser known but brilliant voices of friends nourished me greatly too, and to them I owe more than I can say: Ashley Ramsden, Fox Ellis, Annie Menzer, Brian Kirven, Dan Harrang, Vaughn Paul Manley, Sarah Livia Brightwood, Patricia London. Thanks to all these and many others who share a fraternity of world wonder and wild blessing. Thanks, also, to the dozens of friends, and blessed family, who have encouraged my writing over the years. Special thanks to Alison Luterman for her example and specific guidance in the poet's art.

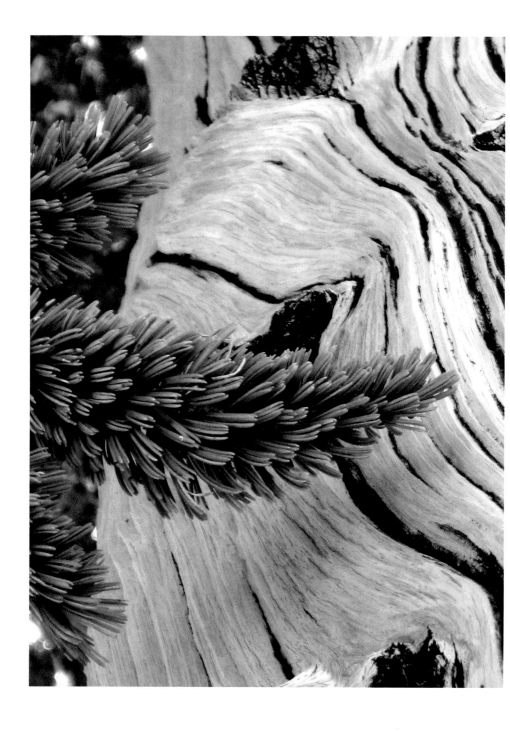

To Love the World

How do you know you love the world?
When the scent of pine pitch makes you cry
When the sound of grass in wind
Is as good as heaven
When stream water feels like a lover's touch
And going indoors is hard to bear

How do you know you love the world?
When a hillside of cypresses in the wind
Sounds like deep rolling laughter
And the breaking waves is your own pulse
In your own body
When a swift streaking overhead
Carries you into open space
And granite in your hand
Silently teaches you
The most ancient religion

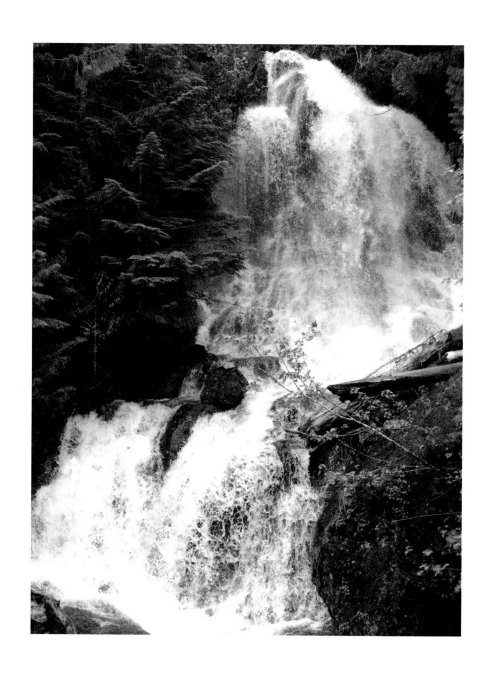

What
Flows

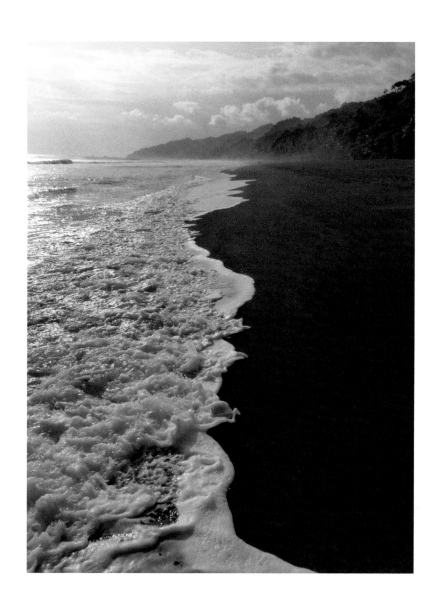

The Call

When you go to the sea edge
To lie down at last
In waving grasses
Grown up the sandy dunes
Listen out beyond the waves sounding water
Beyond the long crescent shoreline
A voice brighter than beginning
Older than ending
A singer-less song not here nor there,
Might carry you skyward
Or out with the currents
Or plummet you luminous into great depths
That bursting summons welcomes you
More sweetly than your mother's voice
Calling you home
To everywhere
You belong.

Hot Creek

We descend from the canyon rim
Plunge into the fingered steam
That rises up from Hot Creek
Swirling all around us
It is winter
Snow on the spent grasses,
On pumice canyon walls, on junipers
The path icy under slipping feet
In the night silence
The sound of water boiling
Up from deep down, up from old Mono volcanoes
Up into the clear cold current
Warming this stream fresh down from snow mountain

On the sandy bank now we strip shirts
Kick shoes peel pants show goose-bumped
Skin to the wild moon
First winter moon
Shining on the water, we enter
Current, fast icy
Swim hard hollering!
Reach warm swirling up rock juices that
Caress and tease.
Ow! Hot! Ai! Cold!
AH WARM AH melt into water
It comes as it will
Like life
Like life I search for a comfortable place

Hands flutter at my hips, here, there
Drifting, seeking
A place
Where mountain top and mountain root
Blend in the balance
What feels right: good, deep, warm

Find the edge of an upwelling
Luscious, rich hot currents sweeping
Over arms-hands-fingers-toes-feet-trunk-self
ALL OVER — Ahhhh
Aaiiii! Cold hands grab and slap, sting and shake Ai!
And warm returns again like summer

My friend moves into the shallows,
settles quiet, like a frog
Belly resting against the bottom.
White skin, white sand
 "Warm sand. . ." his voice
Drifts through steam and bubbles
Join him, slide up beside his bare length
Onto the warm grains, still
We gaze up, into the night, stars, fingers dig into hot sand,
The water jet black, faces cold
in the icy winter air
White steam fingers swirl up into deep sky searching

The moon bulging towards full
Night pearl glow turns the canyon magic
Nearby we hear the hard boiling vents,

see dimly in the moonlight
Where the steam is born from deep down,
roils thick

Miles upstream, steep up,
Mountains lift granite 12,000 feet high
Into the black sky where the creek is born
Cold rock under a trillion early winter snow crystals
Kin to this creek, this mist
We are awake under the water
Noses and eyes up like frogs, breathing the air
Watching what is

Under the water I brush my friend's skin, body of water and heat
Sometimes the world is huge
My friend pulls my head to his,
holds my brow loosely
I look out through the shadows of fingers
Between them the stars

At the Mouth of Seven Pools

Hana, Hawaii

I'm swimming at dusk
In the clear mouth
Of the last of seven pools
Waterfalls dropping to the sea in sequence
To where sweet mountain water
Returns to salt, where the sea leaps in
To claim its own.

Small, I wash here
In and out, carried by wave surge
Above pounded rocks
Plunging down through white froth
To clear depths, submerged
I sweep along rock faces
In sea breath

Tumble up to surge and see
Wave-white over black-rock
Swell swash rush rock bubbling
Over all around
With a few strokes, hard pulling like waves
I'm drawn out to sweep up swells
Sea froth washed face

Going with water
Held and carried
The old harmony
Of motion, of breath

Going with water
The old heart pulse
Around me, within me
The wild tossing surf
The wild breaking me

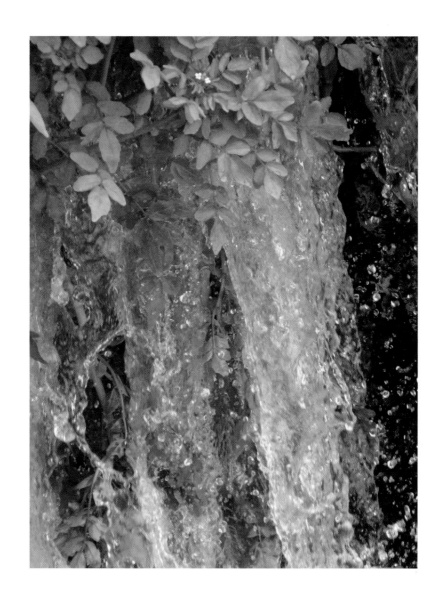

At Home
Makena Beach, Puna, Hawaii

The man-boy washes up the beach in wave surge
Dancing with the sea, seeming as fluid
Then flows back down, deep, as ocean draws its breath
Sliding down sand, swallowed by foam curl
He tumbles willing, given to froth

Muscles roil like sea skin
He gleams and sparkles
Hair flows in currents
Free in sea time
Breathing the sea breath
Washing with waves' ways

Now sudden
He surges
Leaps from the swells
Runs up the beach,
Climbs the cliff
And is gone

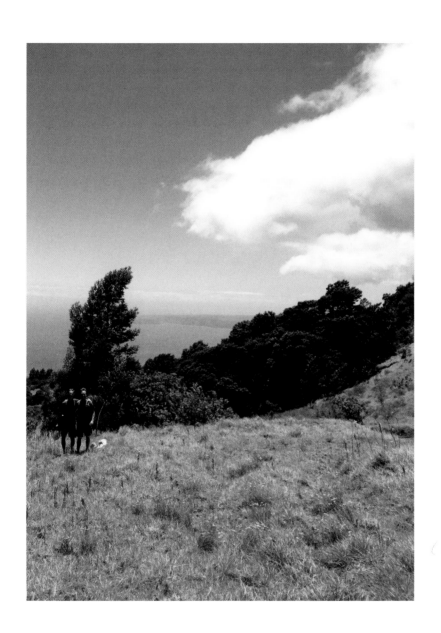

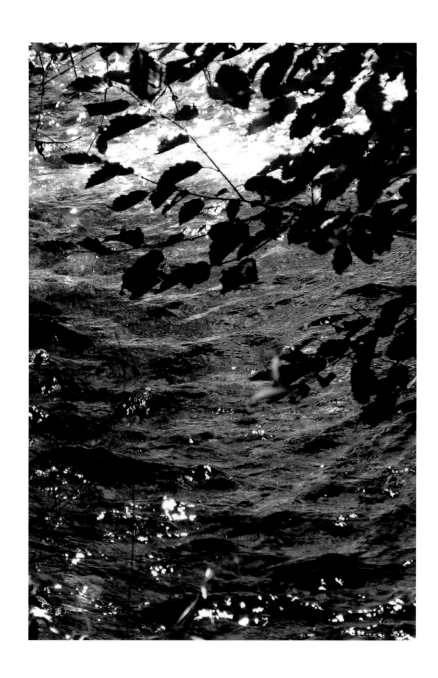

Listening to Lagunitas Creek

Up this canyon
High, in the rocky crook
A whispered lake rests
I climbed here at midnight once
 broad watery cheek
 caressed by moonlight
Slid my canoe over its smooth skin,
 across weight and wondrous depth
Peering into jet clarity
Dark dewdrop in the rocky mountain palm
 in the hollow stone hand
I could rest on this fullness for ages

It's from this lake it springs,
Little Lagunitas Creek
Laughter loosed from silence
Slides down round stones under maples
Under branches loosing last leaves
Gentle giggle, soft song, water whisper

Early, between dawn and mist
Above water
Between shadowed maples,
Leaves fall
Can you hear?

Listening deeper, deeper
Breath slows till it floats,

Hovers, just barely
Between maple leaves

Within the singing water,
 the lake's ancient stillness.
Beneath the lively wavelets,
 the darkness beyond moonlight
Silence holding sound
 Mountain bearing lake

Seconds, decades, centuries tumbling
Wavelet over salmon scale
Sand spit over round rock,
Hidden

Fall into the clear, luminous space
 where oxygen and hydrogen mate
While a wild notion is born
 as water

Run down stream, slip into alder root where water dashes,
 Rush up trunks
 Brook bounding
 through branches
Burst out leaves
 back to sky, swept high
To kiss space, bless light, and
 fall again
 raindrop to dark lake

Water Dawn

Hana, Maui

At dawn, bright water breaking
Sighs luxurious
Then shouts, quick slaps lapping
Waves flow in, through each other
Patterns playing
Water inter-penetrating

Each curving sashay of wave wash
Up the red-sand beach-slope crescent
A gesture new in the world
Just born, fresh, now
Gone like a breath
From nothing, nowhere come
Brilliant caresses of the mythic lover
Never touching the same way twice, stroking
Sand, black rock, each other

Ranked wavelets breathe poems
Multihued brilliances
In shoreward pulse
And seaward gather

In-breath into out-breath
Leftward fielding rightward
Crests and shimmer, trough and hollow
Foam and splashing, curl and banking
Swell and heaving, up-rush, down-rush
Glowing ivory, flowing jade, turquois, obsidian

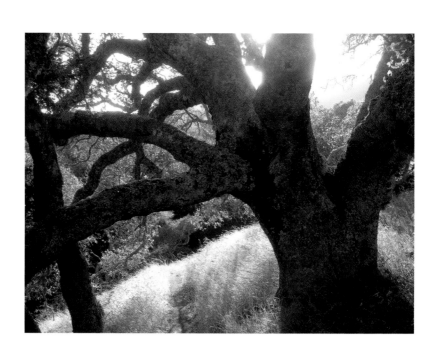

Tree
Songs

An October Astonishment

When I touched the yellow maple leaves
They entered me
Without my knowing

This morning after I'd picked them
I had their golden sweetness
In my veins

It was after holding them in my hands
Upon my skin in the slant light dewy morning
Plunging my nose deep in amongst them
Wet and cold, snuffling
The autumn scent
Suffused into air and me

My eyes fixed on their open hands
Veined like mine
My fingers traced their fingers
Crimson stems upon my palms
Conduits through which
Shape and substance entered —
Mapleness

Only vaguely I sensed
Some ephemeral
Sap entering me

I'd handled the winged seeds, too,
Fuzzy pods full
Of imperceptible roots,
Bark and limbs
A million invisible leaves

I'd given handfuls to the waiting children
They went twirling
Whirling through the sky
Eager, alive with mapleness

Maybe for this
I woke this morning in my bed
Wholly content, bathed full,
Astounded and swimming
In that amber light that hovers
In and around maples
On crisp mornings
In October

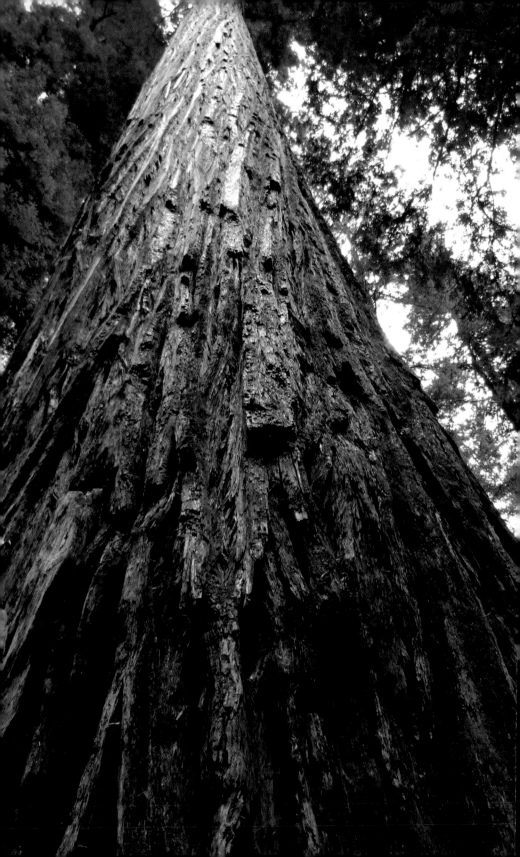

Audience with Sequoia

I.
Dirt road climbs
Winding up
and around, and up
Through chaparral, bunch grass
Buckeye, redbud
Shadowed canyons, wild ridges
Opening
Tawny layers
Glimpsed way down beyond
Lines of mountains
Shoulders, ribs, thighs and feet
Shades of haze
Gray pine, deer brush, broom
All paint the day
All spread out from old river below
Barely heard

II.
Swing around to north now
Drop into ancient timber
Thick-boled, lush-needled, uprising
Long-limbed fir, sugar pine, cedar, Jeffrey
Swirl of scents, sharp as hawks' calls
Washes nose to heart
To ground for feet
To understory flaming with
November dogwood

Round purple redbud
Tucked in by turning maple
Splash through conifers
Like breaking whitecaps
The color free enough
To dive into

III.
Now we see them
Dawn-red trunks
Ten times thicker
Whales among seals
Bears to foxes
They don't narrow down!
Just ascend unchanged
Skyward, climbing, broad
Through feather branches of
The little conifers
Loft above their cousins' light tips
Millennial columns of
Captured sun—centuries' rain
Sequoia!

IV.
Approaching from a distance
Treading on quiet fronds
Through brush of needles, to glimpse
An immense trunk
Head flung back,
Scan up the wall of bark

To sculptured branches
Sprouted like whole trees
Canopy a massive plume
Conversing with mountains.
Tears
Quiet

V.
Three thousand years
Of being
Here
This place
Storms and sun
Full moons, new moons,
Cyclic fires
Rains, fog, centuries' roll
Skittering footfalls of a thousand generations of
Climbing squirrels, high trill voices over
Centuries' fronds,
Wind song
How many starlit nights?
Summers endlessly returning
Three million cones grown, and dropped
A billion seeds
What is this
That stands before me, above me?

Willing

If I were maple sap
I'd relish March's leap,
Limb rushing up
Leaf waking toward light
As November's fall
The rootward plummet
Cold wood down to dark

If I were maple
I'd embrace the bleeding
The boiling to thicken
The winnowing of sweetness
As what's water in me
Rejoins clouds

If I were maple blood
I'd course glad through red roots
Grown rashly, reaching
Swaying to wash
in the clear brook's current
Stretching thirsty for life

A Boy's Winter Garden

On the steep slope above our house the prickly holly stood
 deep green and berry red
surrounded by snow
 as with clippers flying, wicker basket waving
Mom swept holly cuttings kitchenward
 amidst fragrant fir fronds and cedar sprigs
plucked down from our skyward stretching giants
 by winter winds of last night's storm,
while we slept safe in our beds, amber
 pine-wood walls cradling

Our tree-house maple – since October tumbling grand piles,
 felt-yellow leaves we'd land in face first
after catapulting down the hill with a whoop –
 now stood December-naked, smooth,
Grey-green graceful in the winter cold,
 biting cold that made the rhododendron leaves
droop like dogs' ears in their beds,
 but on our warm side of the pane
white amaryllis and scarlet poinsettia
 shone brighter than the spitting hearth fire

Apples

September was for picking apples
From the branches of my buddy's tree.
Off the twig, into the mouth,
The flesh streaked through rosy pink
Sweet and crisp as nothing I knew
Save friendship.
We'd eat three or four,
Run off, play, come back for more.

College did not cure us.
Crisp fall mornings we'd pedal
Down abandoned orchards
Lean our mounts against the trunks,
Then up, to
Shake branches till leaves rattled
And apples fell red by bushels
Or so we dreamed
Thumping the frosted grass
Jump down! Gather and pass
Wormy ones and all
Bike home with backpacks full.

Those after picking nights steam drifted
Up from applesauce pots,
Pies baked in the oven while
the rare virgins (no worms or bruises)
We'd relish one by one
Over crisp days that followed.

These were old apples
Musk-flavored like wine,
Coarse fleshed like kale
Of trees that outlived their planters,
Their houses, too,
By fourscore years.

Some had rotted with the houses,
Save for one strip of living trunk
Spiraling up,
And one branch
That blossomed bright
Spring after spring,
To bear crimson
These fruits we took as precious
Joyfully disdaining the wax-shiny imposters
Stacked in neat rows at Safeway.

Oh, we celebrated the worms!
They protected our crop
For them, orchard and apples were ours
Tax free, work free —
We only climbed the trees, to shake
And wake to the smell of applesauce
Lingering in the air
For breakfast with cream.

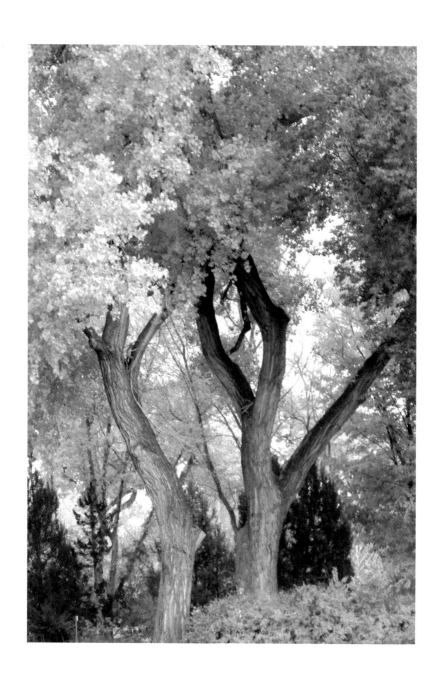

Found Fungus

In my hands these dappled mushrooms
Sprung up from oak roots
Taste of stones plucked from ancient river beds
Odor of sand, pheasant feathers
Young rabbit droppings
The sound of wind combed
Through bare twigs

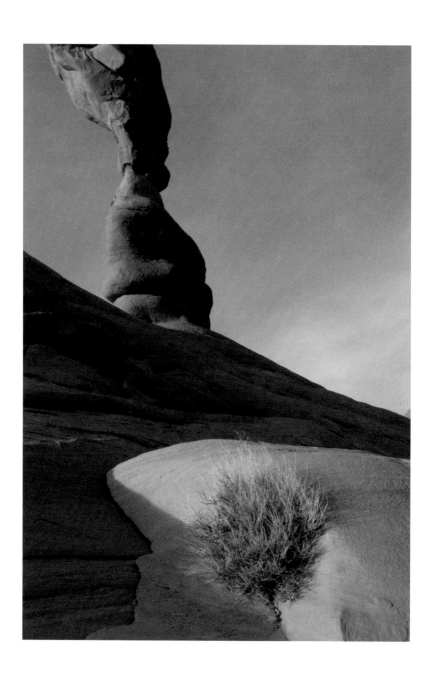

Wind

and

Light

Wind

All night long the firs
Roar glad in the gale while I listen
Through brittle glass, out
Into sinewy darkness where
All about me heaving branches knotted
Tight to their tough trunks swing
Wild and dizzy in the drunken air

Riotous offering, tree tide of tumbling
Jade fragrant needles each
Given grateful to the air's
Fierce caress! To roar multitudinous
Ecstasy, and oh, I cannot sleep
In the company of such
Love making

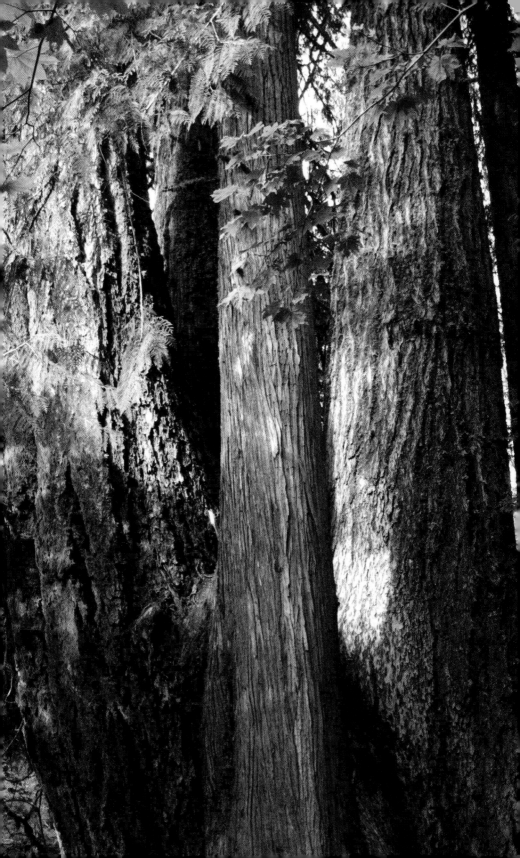

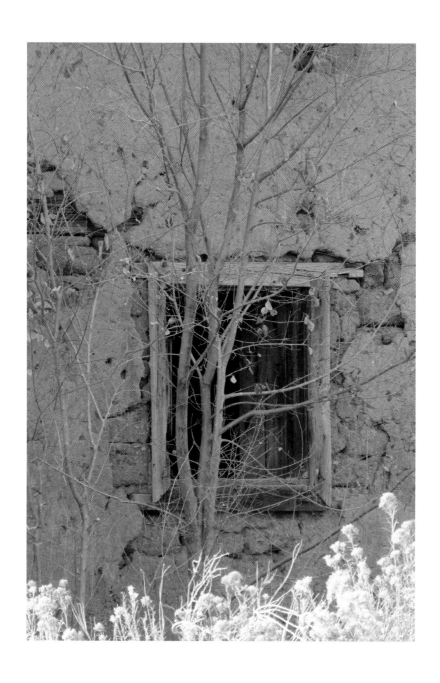

Even a Groaning Life

The morning after the windstorm
We hear of downed trees
A man killed by an oak
Another rolled out of his bed just in time
Trees don't mind dying
To the power that makes them sing
But we are loath to leave
Even a groaning life

Can You Hear?

If I say "wind in pine"
Will you hear it?

Only waves of air
Washing around inside you
Through the limbs of trees
You planted there long ago — or yesterday
Will deliver my words alive to you
Will carry you into
The wonder of pure wildness

Like a dry needle
swept into the sky

First Light

Desolation Wilderness

Curled up
In goose down
My gaze flies

To a distant ridge
Where a single white pine lofts
Black before the brightening morn

Blink — the quick fall, and rise again of eyelids
Look! A luminous phantom pine tarries in my vision
Hovering there, identical, beside its black earthly parent

Mind image, a hair misplaced. Such mischief!
My brain, eager to better see the black-dark tree
Has created its light within me

Everything these eyes see this mind craves more of
Will not leave, but gathers and gathers
Harvests the world like a great whale gulping the sea

Sieves moments back out
Into flowing tides, the rivers of time
As things within time are held
Swallowed, taken up, until

Leviathan, I go cargoed
Bearing a thousand images of light.
Good the inner vault is vast
And light weighs little

Pines, oaks, lakes and herons,
Even mountains — within
Bouyant, lifting
To the same light that births them

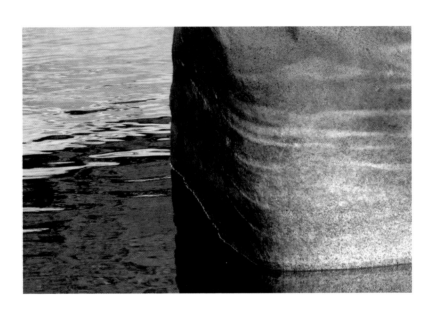

Seeing Is Wonder Enough

This morning eyelids slide back and
The world jumps alive
Endless blue sky
Floods my brain
Birds darting, feathers whooshing
As they fly right into these eyes!

To wing
Along twisting neural pathways
To perch
In whispering oaks
That only an instant before sent their strong roots down
Into my brain's teeming humus

I loll my head sunward and the whole hillside
Bursts into bloom, so many seeds and tendrils,
Burgeoning leaves and petals rush to
Penetrate pupils and irises
Like camels passing through the eye of a needle
To gallop recklessly on into fields of delight

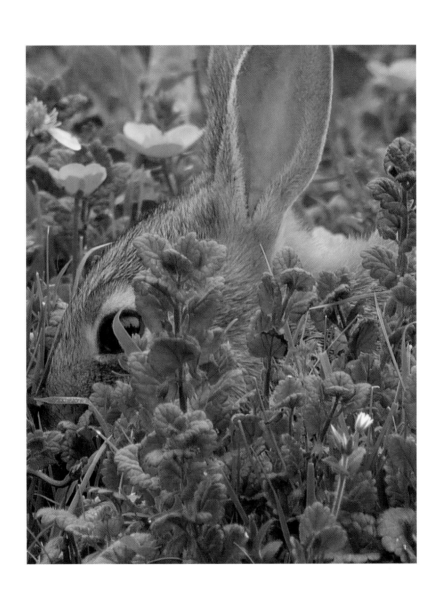

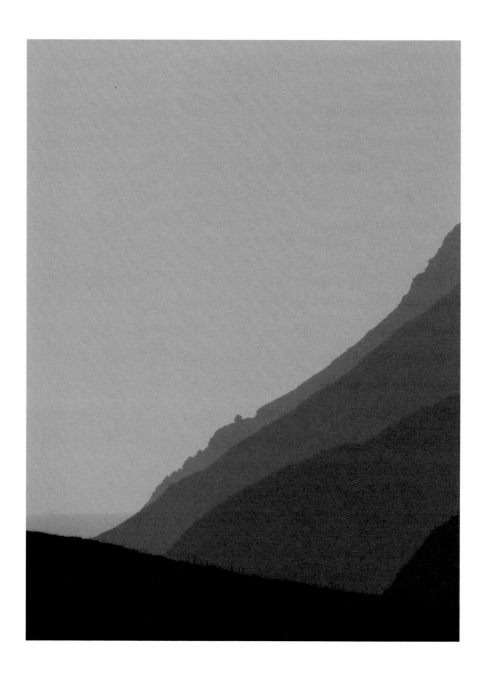

Sky Love

When fog sweeps in off the sea
I'm sometimes called through tall wet grass
Wild grass, upon a wild hillside
To lie in a certain hollow
Where the mist washes over me

Cheek to earth, arms reaching wide
Fingers twined in dune hair
Bare torso licked by a clear multitude
Of miniscule droplets
I lie still and surrender

Believe it or not
I feel each one fall
Like a bright, cool kiss
A tiny explosion of light
Upon my broad skinned surface

How can I explain?
Can any human lover kiss
In a hundred places at once?
Or with such brilliant lips?
But love doesn't last

A pale blue cast slowly takes the sky
As sunlight wins the hill
And my tiny lovers vanish,
Taken up
Into who knows where

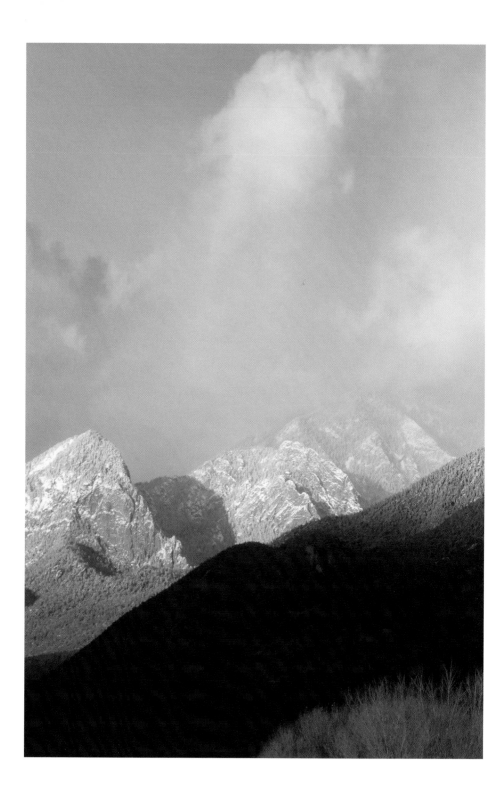

Into
the
Mountains

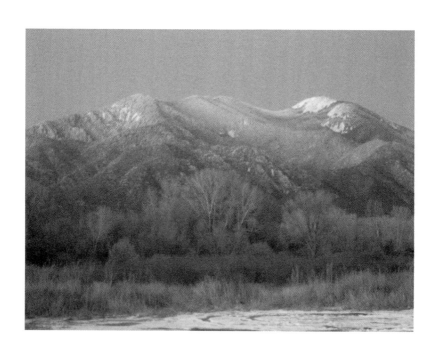

Taos Moutain Haiku

Cold down from Blue Lake
Stream child of Taos Mountain
Grandmother draws water

~

Icy mountain hair
Aspen branches rise, bare
Frozen fire in winter

~

My two old mothers
One gives hot oats, tea at dawn
Other, distant, snowcapped

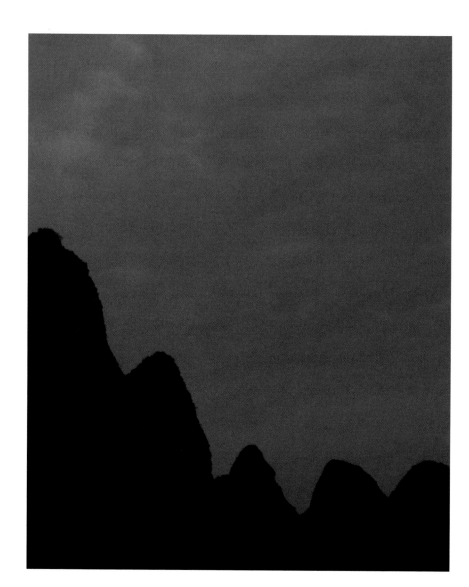

Yangshuo

Only once before
I wept
Seeing a landscape swept before me
Yosemite in youth
Coursed tears down my cheeks
Waterfalls over stone

Thirty years later, across Li river
Seven karst peaks comb the night sky
Upstream from Yangshuo
Like an old sage's fingers, and me
On my balcony since sunset
In the grasp of their beauty

Peaks, just now gold, jet black
Breath steams the January frost
Stars come out
Darkness hovers over willow banks
And still I cannot go

Water fills the night with singing
Peaks whisper something I've almost forgotten
Ah, my cheeks are wet again
Li River flowing south
Towards Yangshuo

Illilouette Canyon

Tucked into a rock cleft and trembling, high
Up the valley. Raining hard. Thunder
Booms down the canyon below,
Ricochets between

Towering granite cliffs
Skyward firs trembling in the rain
Rank the roaring stream, chanting clear, reborn
And I, well

This thunder rolls into me
Grabs and shakes me down to mountain root
Rudely wakes me alive, in the true
Old way

No care for soft beds, relishing
Bark-fragment-needle-stone skin
Pine-coney ground,
Smells of wet trees

True comes out shouting
Like thunder
Stone skin, and the wild one beneath it,
Know they've come home

Ears happy hearing sticks crackle-break under foot,
Drip-drop rains gorge rushushing water
Over tumbled boulders
Bound down canyon

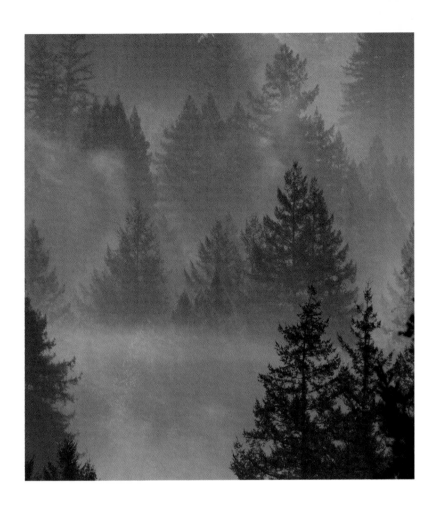

A friend is by
His presence pleases
A region of my mind or body
Near as old as stone

The rain is still falling
Granite bones poke my flesh
Kin, too, here in this nook
Cleft in the rock

The Size of Mountains

Alone, ambling
 the newborn
 slant-light morning

Footfalls crunch frozen ground
 The ringing silence
 Eyes float above the land,
 Raven whoosh

Mile high and more desert
 vast llano
 stretching out from
 Taos Mountain Mother

Smaller dotted mountains as far as you can see
 blue junipers
 sage sea
 winter

 Black Gorge,
 Rock wall tumbling
down to deeper darkness
 Old Rio below
 cold whispering

Fingers tickle icy air
 breathing nostrils crackle
 face glad in thin sun,
 arms reach up, then down

 toes, pull
 tendons taut,
Muscles like junipers,
 creaking
 when wind comes

Then:
 my body feels,
 something more than self--
 feels place – It comes
Up through legs, through cold skin
 Penetrates flesh
 Finds bone

Inside,
 old discontent
 suddenly vanishes
 in cold sage scent

Here, nose down
 to see between these shoes
 dry grass, little clumps
 plain as dust, nothing special
 until something pierces my pupils
 some tiny arrow
 a little glancing shard
 of sunlight

Startled, searching its source, looking smaller, closer, carefully
 until I see it — look!
 A brilliant filigree
 of a thousand tiny ice diamonds ranked
 sharp, clear, spangling
 the length of each wispy leaf stalk

 Mountain ranges!
Let me fall tiny into that little enormous world right now
 Ascend each separate ice spire
 like peaks of the Sangre de Cristo
 to bathe in sun and blue white
 atop each summit

One crystal enough, an ascent to light
 Each stalk a Sierra!
 This hundred-stalked grass clump
 far-flung chains
 Himalayas

The llano stretches about me
 countless grass clumps
 with their countless tiny mountains
 all the way, mountains all the way
 to Taos Mountain Mother

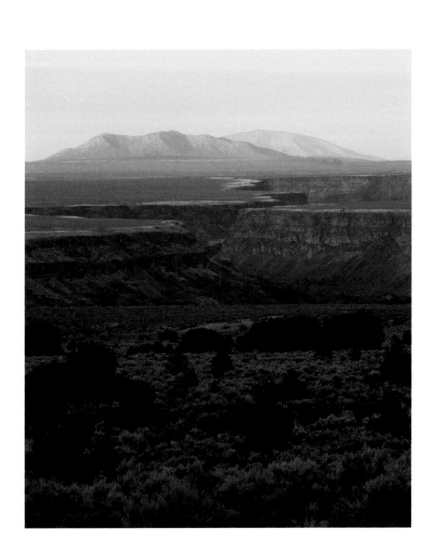

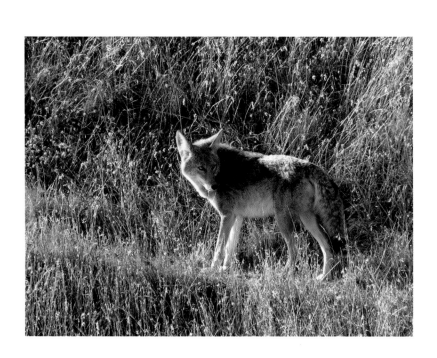

Fellow Mortals

The Secret of Work

Swinging open the garden gate
 first sunrays over mountain ridge
I step to the flowered path, but
 stop short,
Beauty-blocked by the night's work
 of some eight-handed weaver
Concentric rings of dew-diamond light —
 No perfectly sketched circle
Could hold the presence of this
 undulating orb, this seemingly living being
Bowed and rippling sail-like
 in the sea garden breeze

 Ah! There she is
Eating her tiny breakfast
 on the edge of the wonder
Within the weaver, through the night
 her shining thought
Delicate spacings of strand on strand
 anchors of grass blade, leaf, twig, petal
Climbing and scrambling,
 she finds the foundation
Draws out her picture
 circle on circle
Until the last circle she can spin
 is spun
And in the dark dew falls
 silent, unseen

When dawn
 streams over the world's edge
Her creation shines!
 billowing,
Breeding with sun shafts,
 answering air

I think of my own trembling life, my
 measured, plotted lines
Drawn by hope in the dark, the anchors grasped
 one by one,
Firm as can be found —
 yet fragile leaves and blossoms still —
Giving seeming foundation to my *idea*
 born and borne within me

I build through the night
 in the shadow of reasonable purpose
But it is the dawn breeze
 sudden shafts of light
 invisible dewfall
Ineffable presences
 that ignite wild life
That kindle surprising beauty in the work
 making a living, glowing thing
Of my deliberate, well-planned intent
 my awkward and tenuous effort.

Wild

"Mega-pod !" —our young captain hollers
 Muscling the wheel westward
As ahead, turbulent waves
 burst with a thousand tumbling bodies
His eyes flash bright
 as those sleek, wet sides
We cleave the water for them
 They surge to meet us!
Stream past the hull
 all airborne bounds and plunges
Shooting the clear
 translucence of their element
Potent, charged as the sea
 pulsing, carefree purpose. Porpoise!

Electric torsos, eon-crafted
 belong here, perfect as the breaking waves
Emerging and reuniting with their source
 Fusion of will and joy
"Common dolphins," our captain proclaims
 "Common miracles," I whisper
"They can't survive in captivity," he tells us
 How could they? I wonder
Separated from these clean, flowing depths,
 from the elation of a thousand leaping comrades

From the wild chase
 of flashing fish
Wouldn't we die, too, if slowly,
 torn from the elements we sprang from?
Trapped in filtered tanks, fed dead fish,
 no longer coasting open flowing currents?

Are we as alive in our pleasant
 box houses with pay checks, as
The Chumash were
 on the wild island shores
Swept by winds and tides
 by immense mysteries?

Song and Silence

snorkeling south of Makena, Maui

Above, I float on transparent space,
Peering down into their world.
Below, they glide in liquid clarity
Jet black fish saucers, all
Stroked with a single
Sleek silver stripe
Tails quiver while
Sea lemon explosions
Flash by in schools of tiny thousands

Grand ladies parade,
Eyes made up for the opera,
Lips wildly painted
Fin scarves streaming in the tidal wind
Studded blue-jeweled tails
Multi-colored fans, polka-dotted dresses
Pupils dark in amber-gold windows of fish souls
Innocent, suspicious at once they look as they
Flit, glide, curve, feint
Matron ballerinas of the reef

Swimming unicorns
Mass in a watery herd
Stampede silver-silent below me
Peer upwards into my face as they pass
As if I were a fish God
And deeper down, a green shadow
Moves through green shades

Sea turtle, you old
Crescent-finned bald-head!

Let me kick gentle now to trail
Behind you, just above you
To glide on a plane above, parallel
Until, too enchanted, called by your grace,
I descend to seek you, longing
To enter your mystery, old sea hermit
To somehow climb inside you —

Ah . . . hear those faint notes?
Those rising calls, those booming tumbles
Whale songs! Humpbacks!
Out beyond the reef they sound
Chanting their long songs
Fifteen-foot fins flying in the salt green sea
Their voices reach into me
Whine into my salt blood
Sea born, cascading through octaves
Counterpoint to the glistening waves, the
Sea wind tide, wild sea song

What are they singing? Never mind.
Hearing them, enough, and old turtle
Humming silence

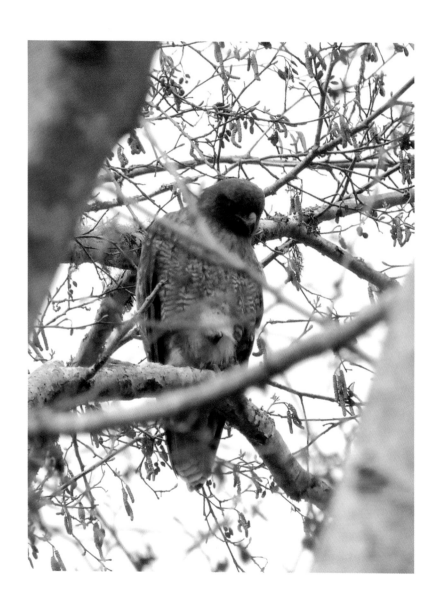

Hunter

Grey-feathered hunter
Sweeps arcing over open
Through scattered pines
Tucks in light
Between limber limbs
Whoosh, flutter, settle

Bow bends, bounces
Feather shafts fold
Gentle on quivering, hollow-boned body
Look — the goshawk sees you
Fiery eyes searchlight fixed
Muscle and taut sinew

Trigger tendons tethered in keen brain
There, presence intent,
It finds what it seeks
If I had such keenness
If what I sought
Dwelt so singly within me

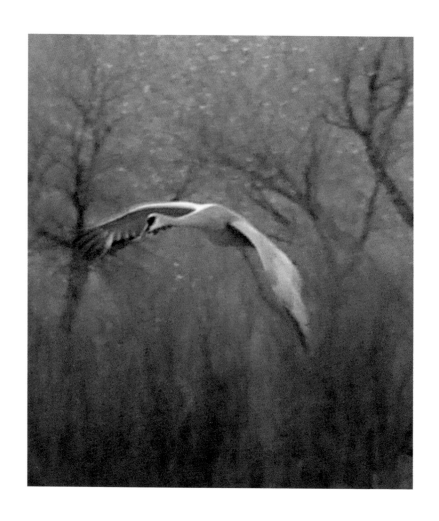

Wild Taste

Things with faces I honor by not eating them
But earth peoples eat and honor
Following them I nibble solstice sacrament
And the taste of wild duck catapults me
Head first into the world

Icy water splashes my feathers and feet
Bitterness in bill of bottom weeds
Gritty grains, grass
Pushing up through lakeshore mud
Wind wings whine
Cold over eyes, curved neck, carving tail

Dawns – mist – silence – night
Morning beams
Lapping waves, reedy rustle
Down seasons of sunsets
Staining rock-margined lakes
Splash-downs on reflected mountains
Sleep upon billions of stars, head under wing
Dreaming flight

I swallow.

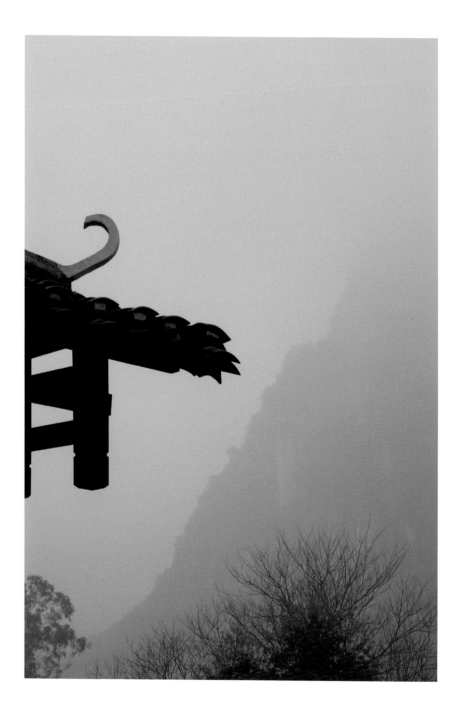

Of
Nature
and
Human

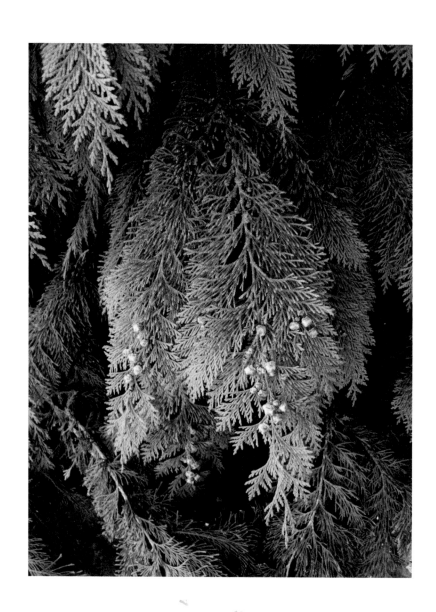

Frond Memories

I.
Those cedars
that towered
over my boyhood home
vexed mother
when father's death
left our gutters
unfended
from their fronds

II.
So I perched,
newly appointed,
splayed-kneed,
heart a-flutter,
heels hewn
to slippery
wooden troughs,
cleft to stave off
the imagined tumble
aching my soles as
purple hands
plunged numb
to plumb icy
tree fingers, soaked
and tea-leaf spent
plucked out
and thrown down
by fistfuls

III.
Shuffle butt
scratch-down shingles
finger skin wrinkling
shadows growing
sweet scent
of cedars, shivering
in cold deepening
October air

IV.
Digging done
lawn littered
hands raw
from sodden cedar
haul the heavy
green cracked hose
across soft moss
roof crest
eager to wash
final fronds
along their way

V.
Crouched at roof crown
I pause a moment
held in silence
hear my breath
lisping
leaf sounds

creak of tree joints
sensing roots' reach
under old fern duff
where they stand

VI.
Down drain shoots
cold water clean
white thumb pressed
to metal hose mouth
water flow forces
leaf jams free
opens the way
for rain to flee

VII.
Dark comes
before done
descend the rungs
last light dim
satisfied, longing
— for hot bath, steaming soup,
slippers, supper
cedar fire flicker
and flannel

Enough for today
I'll rake
tomorrow

Night Not Alone

Barely visible, this ink put down under
Moonlight. Night so still air rings
Skin moist still with steam
Spit from the red glow of sweat lodge rocks

Feet tight, chilled with
Walking the long wet sand beach,
Emerged from glass black waves,
Bone cold

You are here in this silence with me,
the rest gone home
Here with the night,
and you — if only in mind —
Who feels the night as I do

Wildfire

The flames that burned these grassy hills by day
Chased hares and does, quick fired gold waves to soot,
Shine brighter, though quenched, as amber dusk fades away,
In scattered brands, slow embers that seek the root

I stand amazed: above flame red clouds stream the night
How swiftly the world can change — look
Familiar comfort, order, in a moment's rush of fire take flight
What we know so well is not sure; all this the ashes took

The hills are black now but strewn with strange, new light
And I see a dozen paths I never knew were there
Open ways where before was only fright
And there's an odd peace, a freedom in the smoky air

Uncle George's Apples

Too old to climb now, their knobbly fingers point
To a wooden ladder in the big apple tree
Bright orbs, galaxies wheeling around me
Leaves lighted with October's
Soon setting sun
Feet ache in dark crooks of limbs
Pick and pass,
Handing smooth treasures down
Ellen and George reaching up, smiling, chuckling
Autumn faces gazing backward

Over decades
So many!
Buckets fill and still there's more
Harvest of laughter and seasons
Companions, generations, hardships, secrets
Wormy ones, rotted, and many fine — delicious
Hands, feet, ears, eyes, skin, stance, voice
Laughter, scent, ways
Old ones do not fade
October light in my eyes
So many years now

Finding Life

Struck, the sparrow tumbled from the fence post
Thrashed about in the tangled brambles
My boy's heart leapt out my mouth
And body followed after

Driven to find what I had just destroyed
BB gun hurled down, I ripped thorny vines
Chest throbbing, ears roaring, eyes darting
Wild passion turned horrible
What I would do I didn't think

The little life evaporated into silence
I stood stunned
By the trees
Who had witnessed my murder
And was changed

Running

He's running
Down the road, hard
Rain pounds, he's slick with it
Brown young man
Maya, Yucatan

Holler out the window
Subete — A donde vas?
Climb in - where you going?
"Gracias," he pants
Round face smiles and scrunches
No work! Much rain!
No work for weeks!
I run, run . . . I run!
No fighting! Better run

Have you eaten? Where do you sleep?
Not much. Anywhere.
Can I take you somewhere?
The church, the church, five miles there –
To talk to God.

But God is not home,
His door is locked.
Tears squeeze down cheeks
Just wet with rain

I could offer him a place tonight
I think — warm bed, dinner, talk
But my papers, my bills and my prudence

All scowl and shake their fingers
Sternly

Don't be foolish!
Those fingers wag
Yet what worse foolishness
To ignore the pain of the world?

Innocence

I.

Ignacio Ramos, twenty, my solid-as-a-rock worker
Begins to burp
Swallowing air and erupting it back out
Toneful and delighted
Sober Ignacio
Cheerful, yet never frivolous
Seems dumbfounded by this new-found talent
All morning he burps and chuckles, burps and chuckles
And all afternoon
It doesn't matter if we're listening or not
We do listen, and wonder
If tomorrow he'll settle down. He doesn't.

II.

Young Maverick, four, wails watching us root out
His big Tasmanian tree fern from the garden,
Shrieks as we cut the long, swinging fronds
Carry the stump to the truck in a bucket
 "No! No! No!" he cries
His face twisted, wet with tears
As my hands with fern juice

I've seen him here,
Climbing, crawling, swinging, sliding
Between the streaming light and
The shadowy branches
At home like Adam

III.

Several cars are stopped on the freeway shoulder

A man has a cell phone

A small deer struggles to its feet, hobbles

Across the pavement, stands

Twisted and confused. Falls again.

Dwelling Place

Morning fresh, sky whispy
Taos Mountain in thin clouds, all
The world seen

Or gathered in by hidden
Eyes of mind, becomes my
Dwelling place, where

Coyote gaze, brush of stone, toss of grass
Grow a wellness I abide in
Ever more keenly

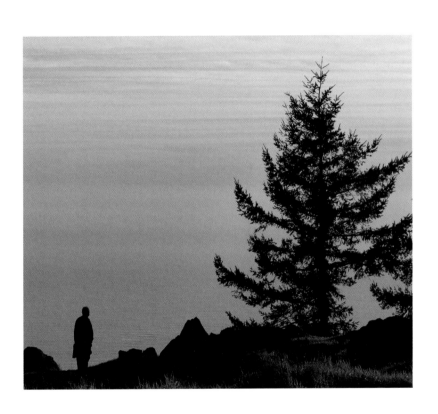

Tree of Life

A bright-eyed matron passes me reclining in the September grass
Mother, most likely, of a passel of well-raised offspring
Going, basket in hand, to that quince tree,
Old and laden with light
Smell how fragrant? though long fallen from fashion

Apple-quince butter, she chuckles, but one must wait
Till they ripen and yellow. Then boil them down slow
Beside good apples, a pinch of cloves, ginger. She speaks slowly,
Her gaze inquisitive, penetrating, kind, to be sure I grasp
The process and sense of it

The tree stands by a stone fallen fence, near a marsh of
Quiet reeds, noisy blackbirds; the homestead house
Gone but for its foundation traces, laid down in days when
Good things passed from mouth to ear and hand to hand,
Before screens and airwaves kidnapped culture.

Then voice and eye, folk ways and family ways,
Carried things on. Good sense measured if a thing were worthy
Of passing along and passing down. Tongue and contentment
Sent a recipe on its way through town; people trusted neighbors
More than hawkers with slick, seductive pictures

She went to the tree and picked, and later I followed
Plucked a few higher up fruits for myself to carry home in hand,
Her recipe safe in mind, to wake up with knife and saucepan,
To savor something shared way back when, by a girl who
Had learned it from her aunt or some friend.

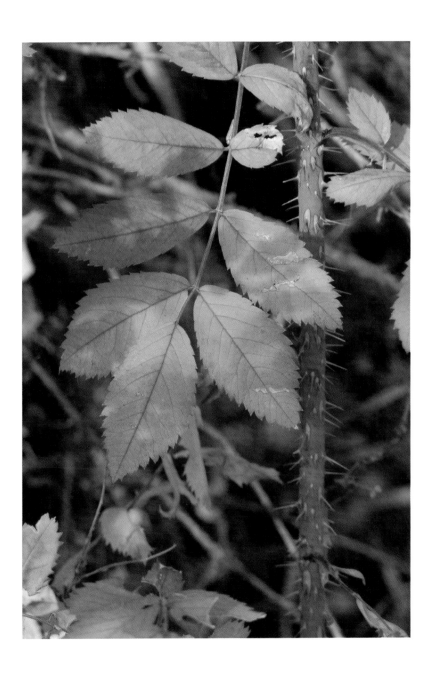

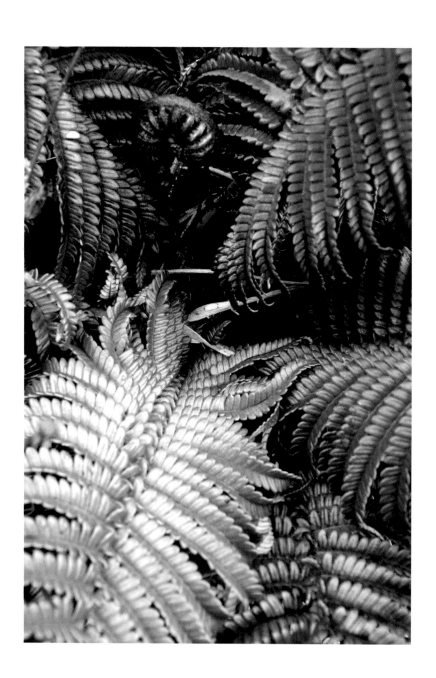

The

Life

of

Things

Night Visit

Rain blew through an open window last night
Fell on arms and cheeks
Half-waking me with blessings
So that I dreamed of love
Not held in human form
No surprise
Haven't you been kissed in the night
Sure, as you drift back to dreaming,
Of some sweet, unseen presence?

There is a Fire

There is a fire that fires you
If you cleave to the heart of wildness
Leaning into the freedom you love
Listening to the hidden music that sings you
What is true in storm as in summer day
Rings through the common life of things
Trunks, wings, streams, stone and all
That fiery music
Will burn you
Alive

Take the World In

Take the world in
Brook upon mountain
Flowering white cloud
To blossom within you
Loosen your small heart
Its blood and its rhythm
To the pulse of the world song
To the ocean and wave call

Let loose the old sorrows
Your tired heart's holding
Grey, tepid yearnings
The hurt body's nursing

Let the world in now
The stream swells the ocean
Currents all blooming,
Storm birds rise singing
Many old healers
Live in your grand home
Receive what you want here
Peace and great energy

How Often?

How often . . . how often —
I'm asking you — this is not
A rhetorical question!
How often do you stop, in the midst
of your daily have-tos
Such endless worrisome minutia
to consider
You are sailing through vast space
On a living, breathing planet?

How often, how often . . .
. . . come now, be honest!
How often do you stop
To simply stand before a tree
and gasp,
"This is a miracle . . ."

(hydrological, architectural,
 chemical, mechanical, phenomenological)

How often, yes, how often,
Looking into the eyes
of a stranger or lover, or friend or
Imagined foe, do you pause to wonder,
"How did star matter turn itself
into the iris of eyes?"

If you are sad, do this.

It could help.

To Know

A spruce waits
lilting to wind, steady in snow
life in roots

A babe suckles
milk flowing out of some
deep source

In winter's depth
I draw from a clear
hidden spring

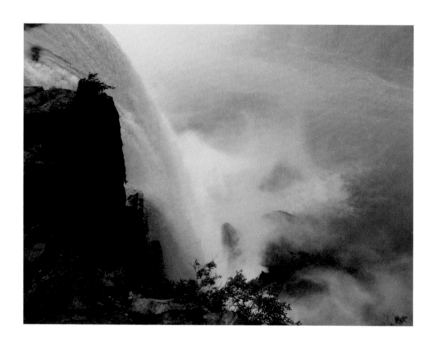

We Grieve While Sleeping

There are clear moments
When I know
We have only to see what is
To put an end to grieving

Nicassio's face washed this morn in finger-rayed mist
A few white pelicans — each its own wonder —
Float on the clear undulating mystery
We dismiss as water, reflecting sky
Hiding stars, just disappeared but there
As geese glide down, toes splayed
To touch the reflection
of the infinite

The morning contains countless wonders I cannot see
Yet I sense a tide of something akin to miracles
Flowing in currents, in bloodstreams, in friendships,
Dreams and kindnesses — invisible stars
We grieve only while sleeping

Photograph Locations

Cover, *Niagra Falls*, photo by Shi Jean Bon Ley
Back Cover, *Montgomery Woods State Reserve*, CA, photo by Fox Ellis
Page 5, *Tenaya Creek*, Yosemite National Park
Page 8, *Mount Rainier*, Washington State
Page 12, *Bristlecone Pine*, White Mountains, CA
Page 14, *Olympic National Park*, WA
Page 16, *Osa Peninsula*, Costa Rica
Page 23, *Watercress*, Point Reyes National Seashore, CA
Page 25, *West slope of Haleakalaa*, Maui
Page 26, *Rio Chiquito*, Taos, NM
Page 30, *Coast Live Oak*, Marin County, CA
Page 34, *Coast Redwood*, Hendy Woods, CA
Page 42, *Rio Grande Cottonwoods*, Albuquerque, NM
Page 44, *Arches National Park*, Moab, UT
Page 47, *Olympic National Park*, WA
Page 48, *Aspen and adobe*, Taos, NM
Page 53, *South Fork of the Yuba River*, Nevada County, CA
Page 55, *Cuckmere River, Exceat*, England
Page 56, *Point Reyes National Seashore*, CA
Page 58, *Sangre de Cristo Mountains*, Taos, NM
Page 60, *Taos Mountain in winter*, NM
Page 62, *Karst Peaks*, Yangshuo, Guangxi, China
Page 65, *Coast Redwoods*, Santa Cruz Mountains, CA
Page 69, *Rio Grande Gorge*, Taos, NM
Page 70, *Coyote*, Mount Tamalpais, CA
Page 78, *Red Shouldered Hawk*, Puerto Jimenez, Costa Rica
Page 80, *Sandhill Crane*, Bosque de Apache Reserve, NM
Page 82, *Yangshuo*, Guangxi, China
Page 84, *Western Red Cedar*, Olympic Peninsula, WA
Page 97, *Douglas Fir*, Point Reyes National Seashore, CA
Page 99, *Wild Rose*, Rio Hondo, NM
Page 100, Waimakanui fern, *Haleakalaa*, Maui, HI
Page 102, *Santa Cruz Mountains*, CA
Page 104, *Cuckmere River*, Exceat, England
Page 108, *Niagra Falls* (Shi Jean Bon Ley)
Page 110, *Piute Pass, John Muir Trail*, Sierra Nevada, CA